NATURE'S BEAUTY
WITH POETRY

by Donna Cook

I hope you enjoy this book as much as I enjoyed putting it together. I thank God for the chance to showcase His beauty and powerful words He has given me.

I dedicate this book to my mother Marie. She was my inspiration artistically and spiritually and I look forward to seeing her in heaven someday.

For more information or to contact me, check out my Facebook page at facebook.com/allforhim. I would love to hear from you.

Donna

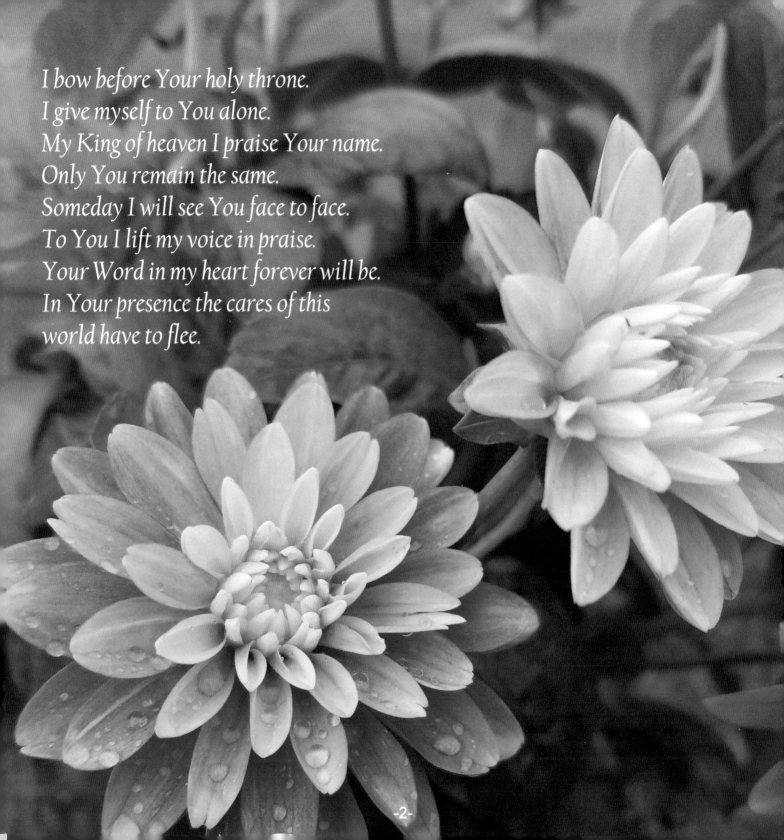

I bow before Your holy throne.
I give myself to You alone.
My King of heaven I praise Your name.
Only You remain the same.
Someday I will see You face to face.
To You I lift my voice in praise.
Your Word in my heart forever will be.
In Your presence the cares of this
world have to flee.

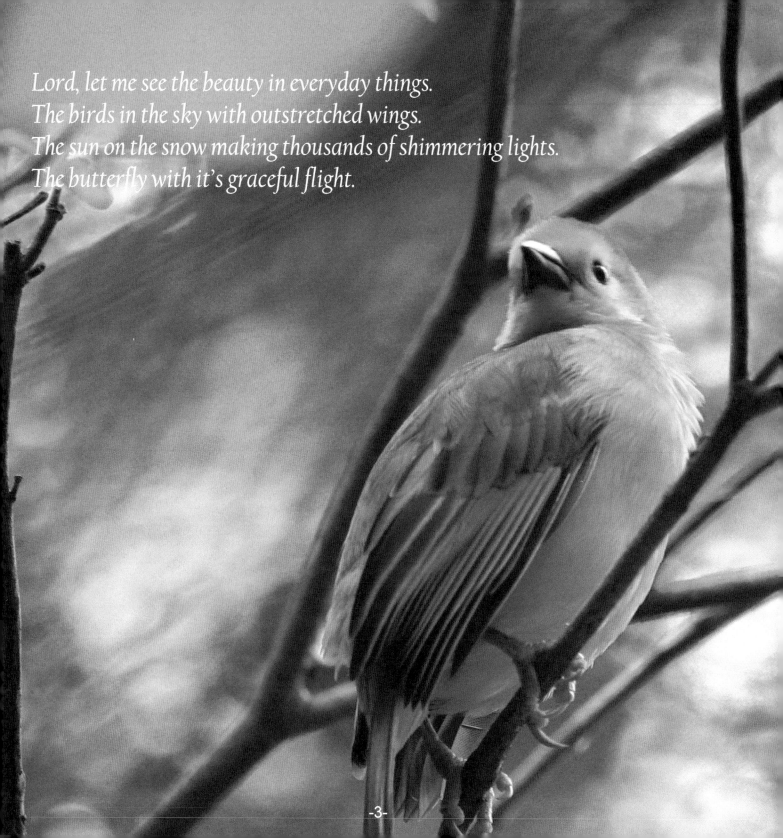

Lord, let me see the beauty in everyday things.
The birds in the sky with outstretched wings.
The sun on the snow making thousands of shimmering lights.
The butterfly with it's graceful flight.

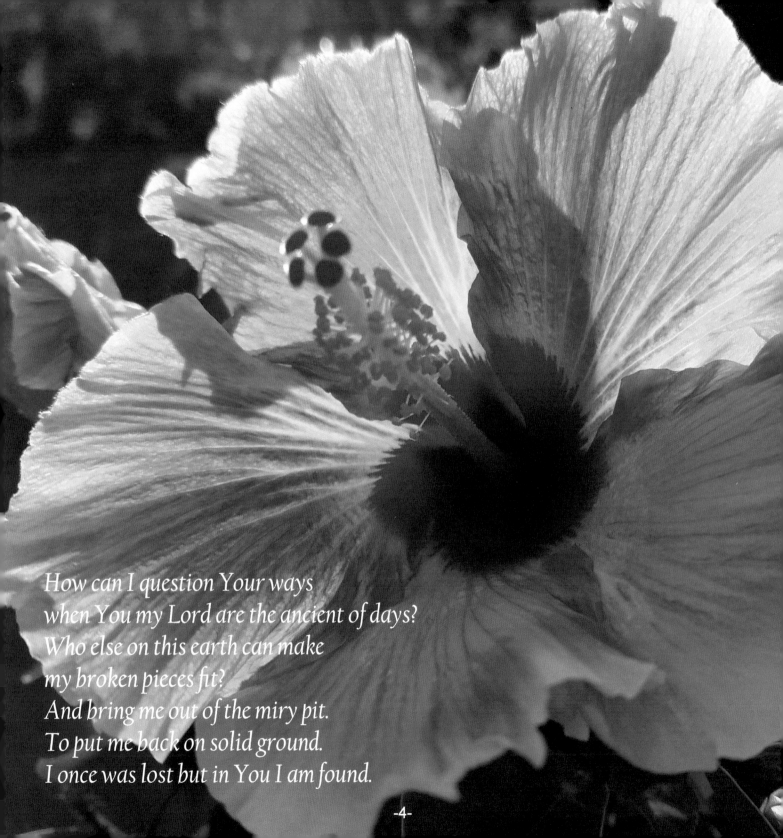

How can I question Your ways
when You my Lord are the ancient of days?
Who else on this earth can make
my broken pieces fit?
And bring me out of the miry pit.
To put me back on solid ground.
I once was lost but in You I am found.

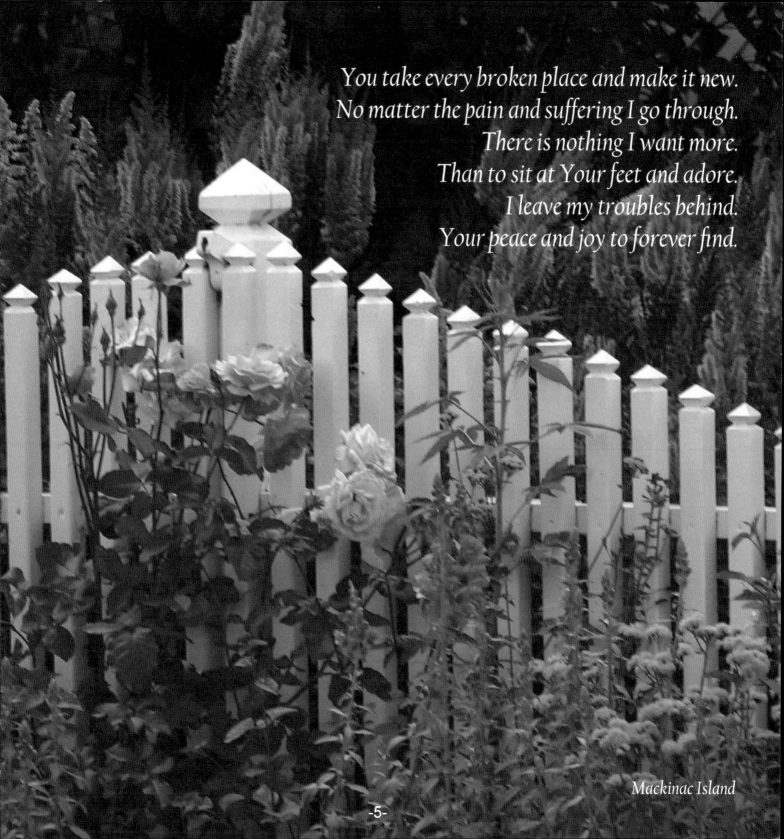

You take every broken place and make it new.
No matter the pain and suffering I go through.
There is nothing I want more.
Than to sit at Your feet and adore.
I leave my troubles behind.
Your peace and joy to forever find.

Mackinac Island

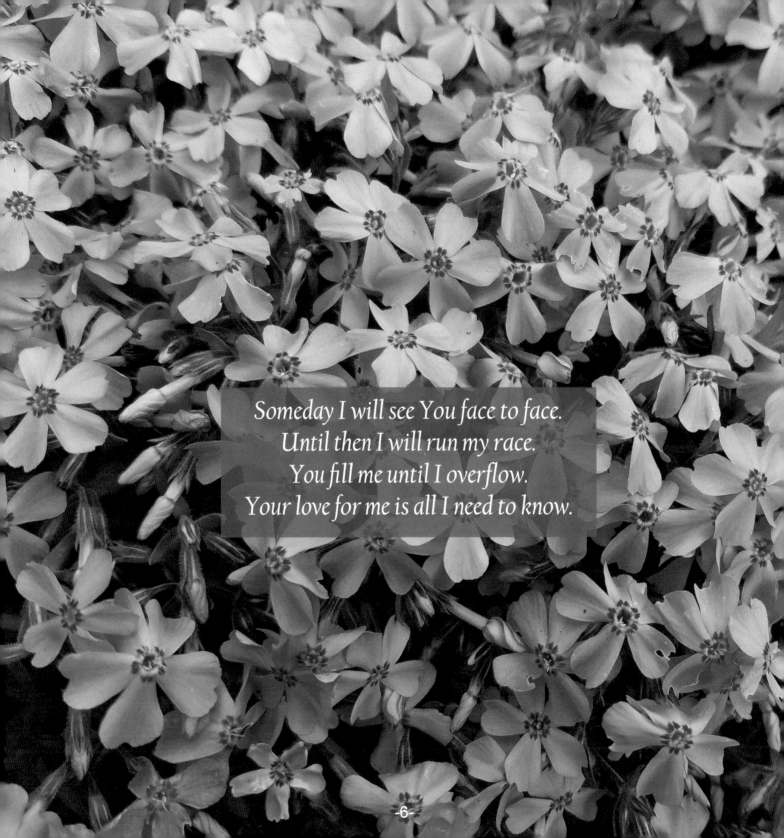

Someday I will see You face to face.
Until then I will run my race.
You fill me until I overflow.
Your love for me is all I need to know.

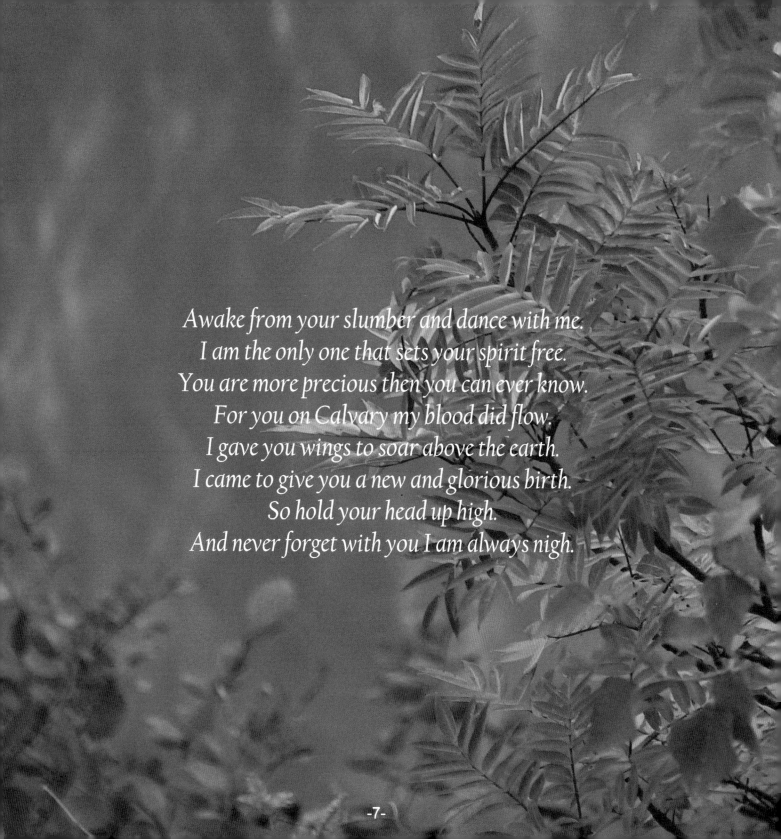

Awake from your slumber and dance with me.
I am the only one that sets your spirit free.
You are more precious then you can ever know.
For you on Calvary my blood did flow.
I gave you wings to soar above the earth.
I came to give you a new and glorious birth.
So hold your head up high.
And never forget with you I am always nigh.

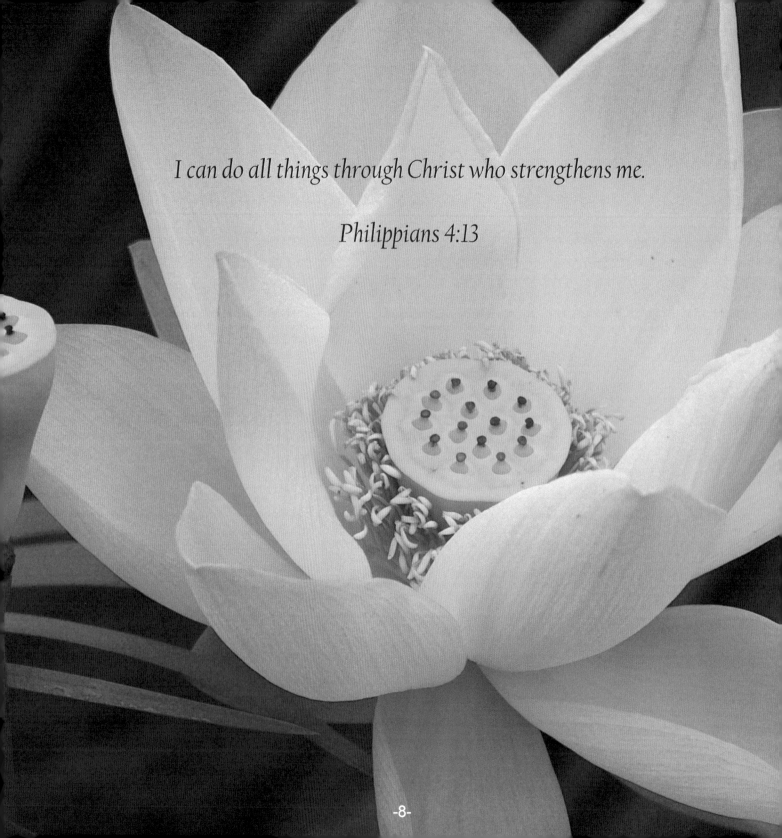

I can do all things through Christ who strengthens me.

Philippians 4:13

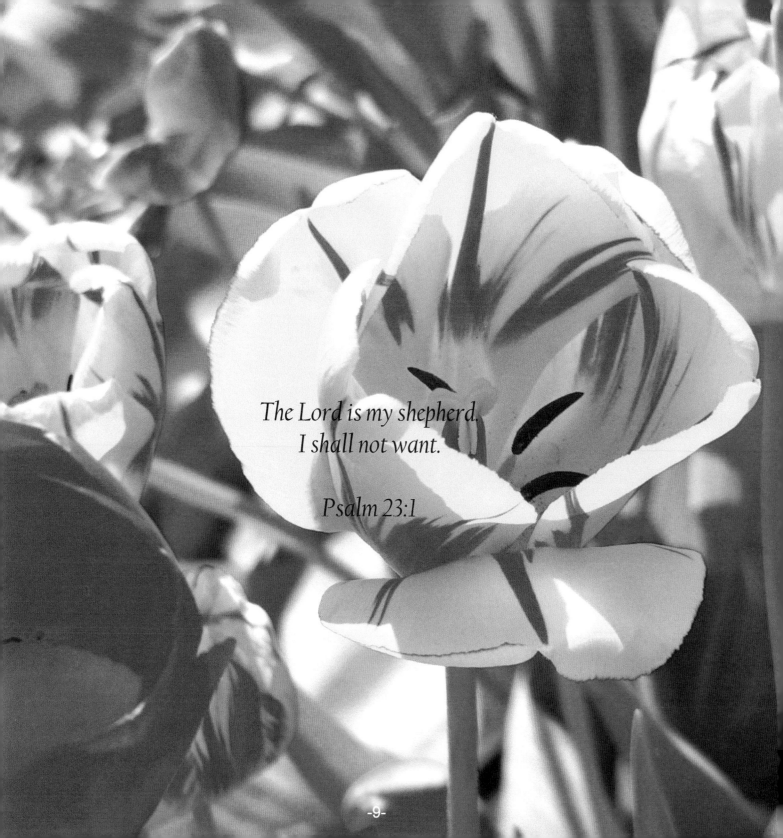

The Lord is my shepherd.
I shall not want.

Psalm 23:1

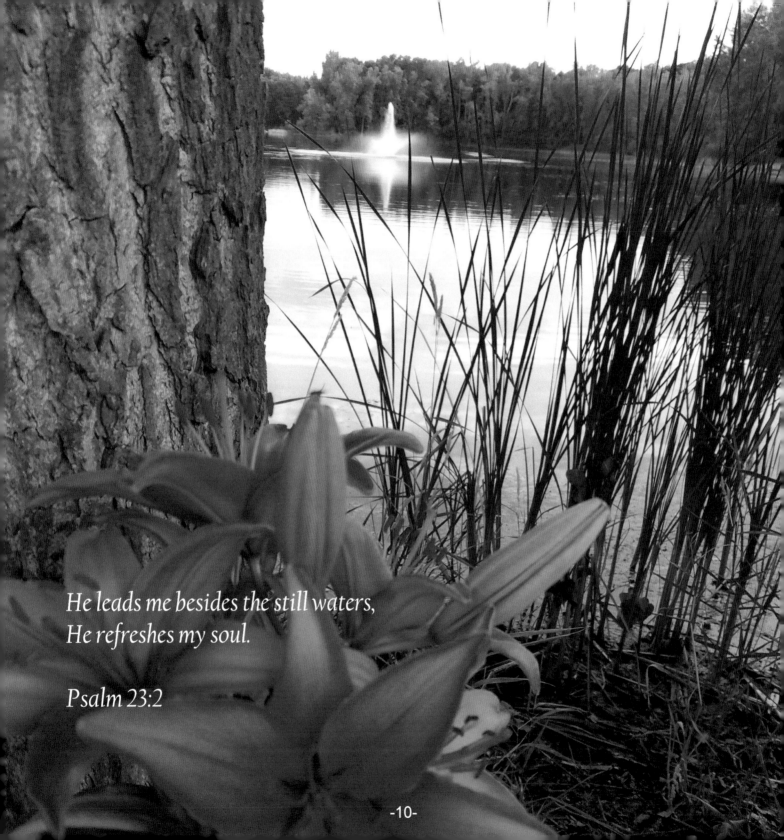

He leads me besides the still waters,
He refreshes my soul.

Psalm 23:2

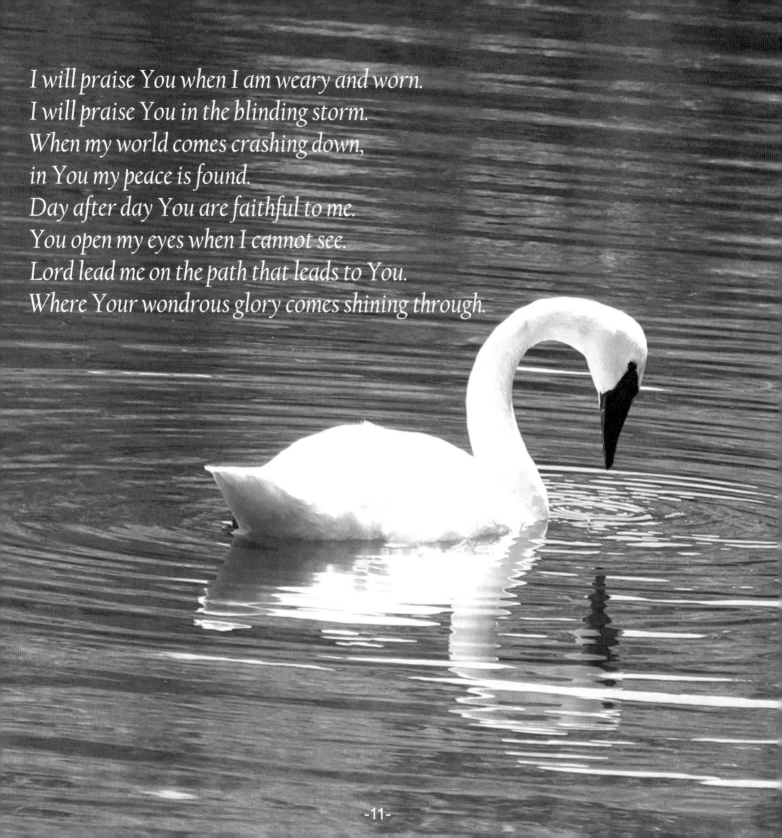

I will praise You when I am weary and worn.
I will praise You in the blinding storm.
When my world comes crashing down,
in You my peace is found.
Day after day You are faithful to me.
You open my eyes when I cannot see.
Lord lead me on the path that leads to You.
Where Your wondrous glory comes shining through.

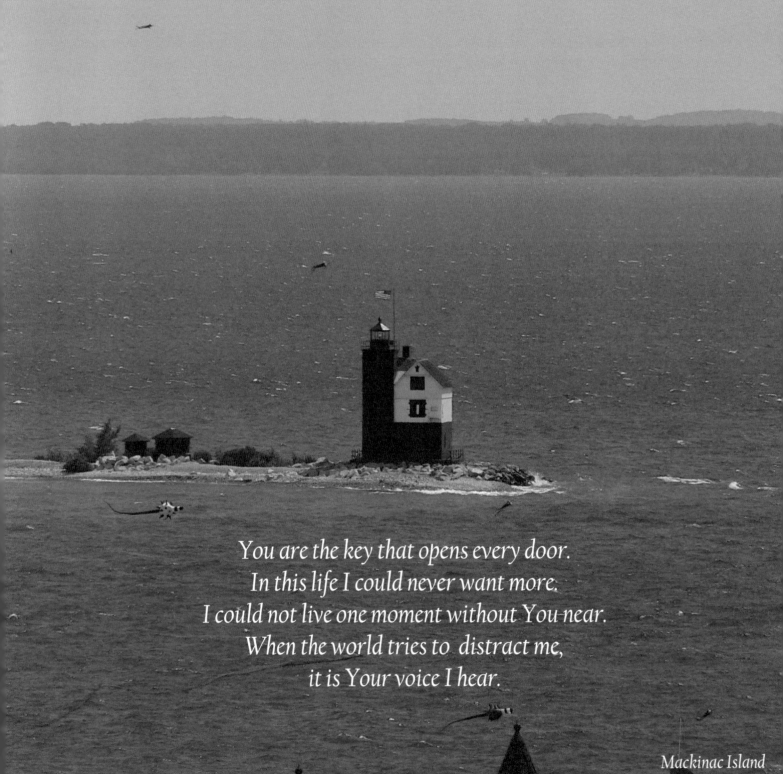

You are the key that opens every door.
In this life I could never want more.
I could not live one moment without You near.
When the world tries to distract me,
it is Your voice I hear.

Mackinac Island

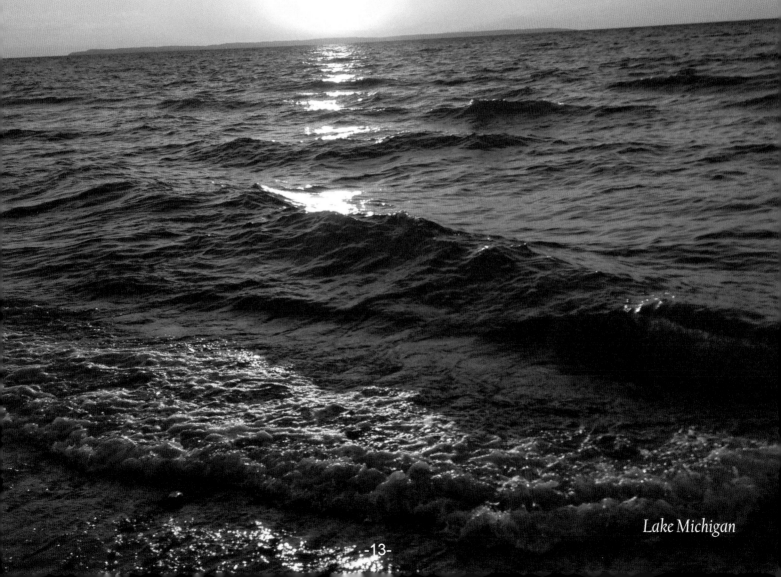

The arms of heaven are reaching for me.
Taking my burdens, setting me free.
You are faithful to the very end.
In this world there is no better friend.
You always turn my gray skies blue.
On my darkest days Your light shines through.

Lake Michigan

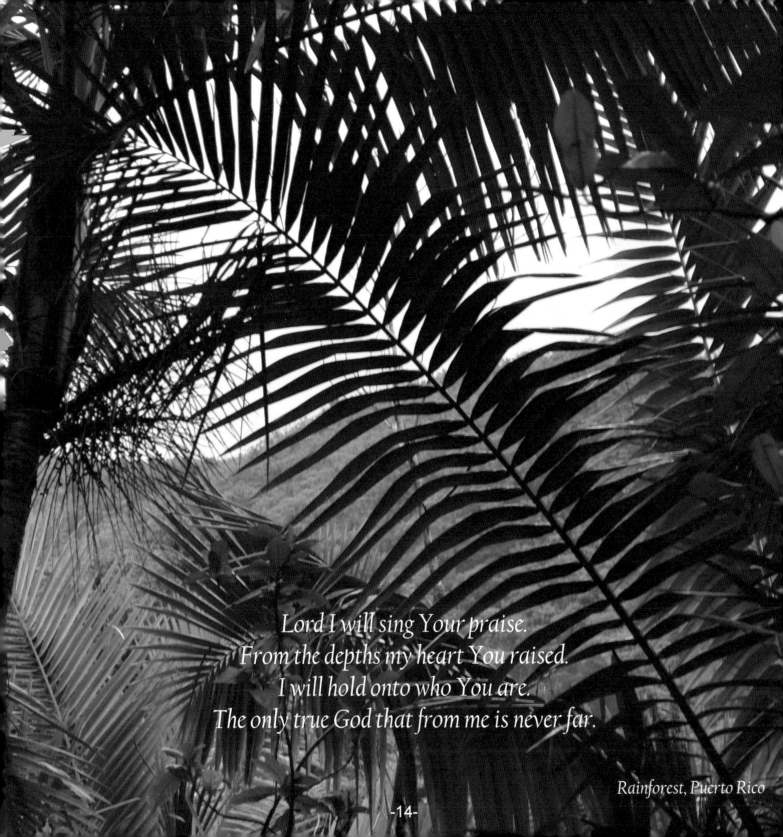

Lord I will sing Your praise.
From the depths my heart You raised.
I will hold onto who You are.
The only true God that from me is never far.

Rainforest, Puerto Rico

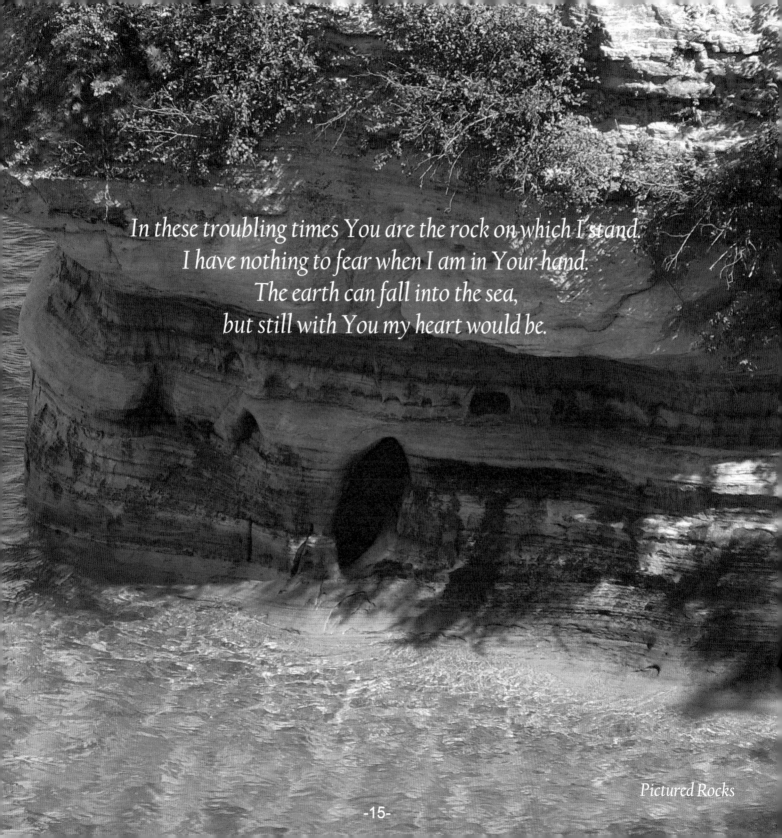

In these troubling times You are the rock on which I stand.
I have nothing to fear when I am in Your hand.
The earth can fall into the sea,
but still with You my heart would be.

Pictured Rocks

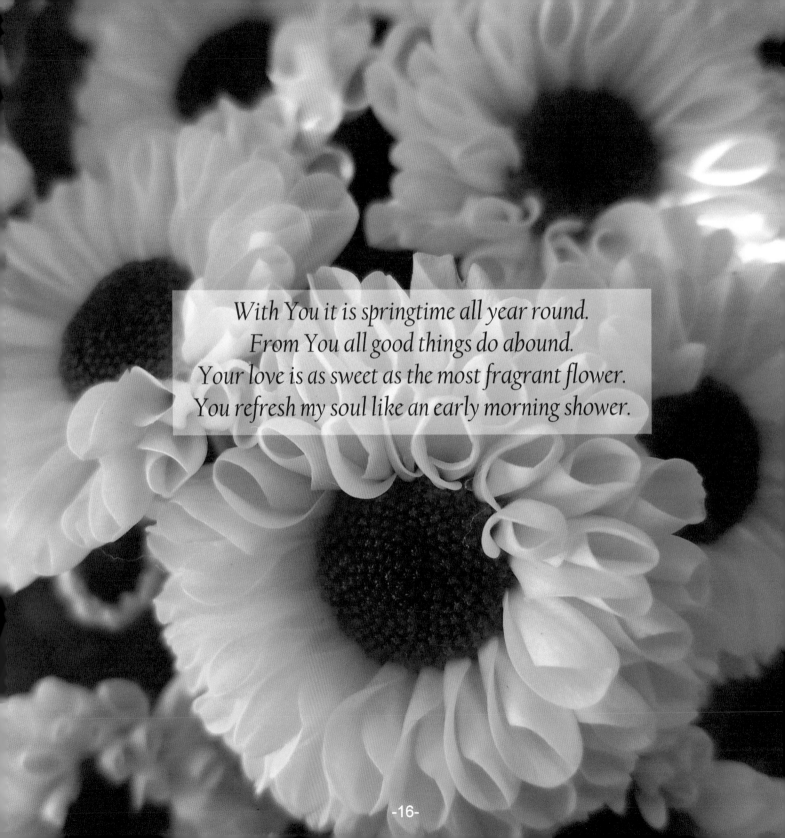

With You it is springtime all year round.
From You all good things do abound.
Your love is as sweet as the most fragrant flower.
You refresh my soul like an early morning shower.

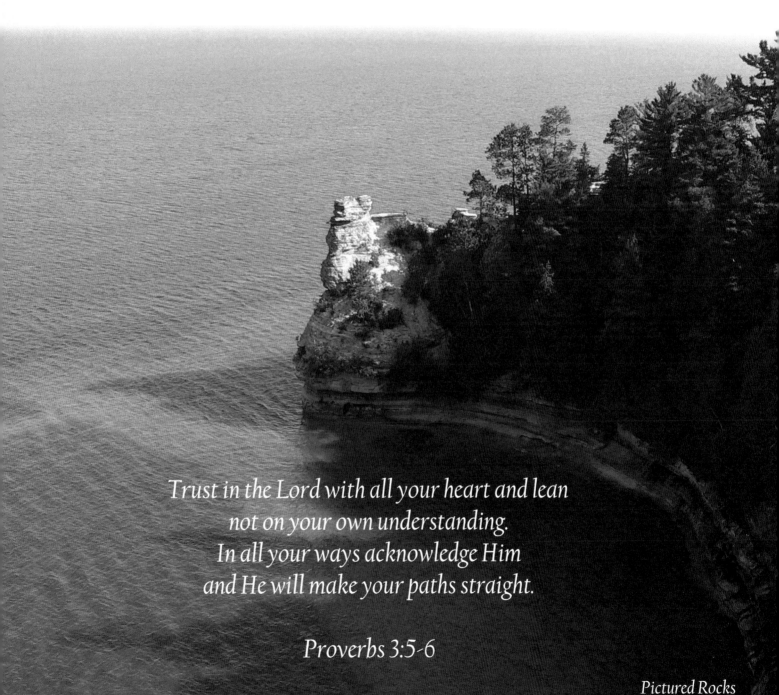

*Trust in the Lord with all your heart and lean
not on your own understanding.
In all your ways acknowledge Him
and He will make your paths straight.*

Proverbs 3:5-6

Pictured Rocks

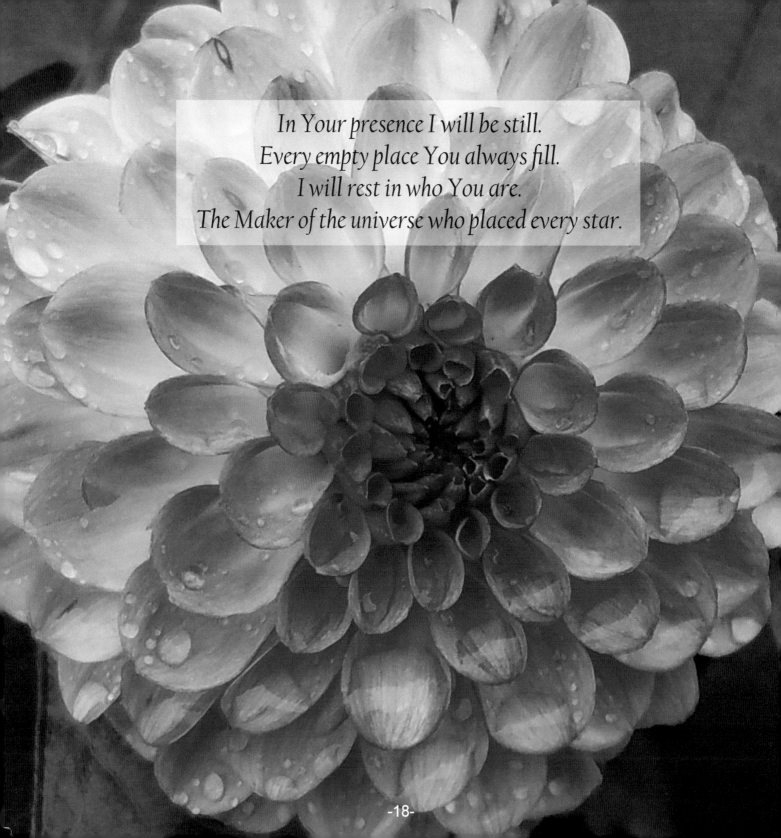

In Your presence I will be still.
Every empty place You always fill.
I will rest in who You are.
The Maker of the universe who placed every star.

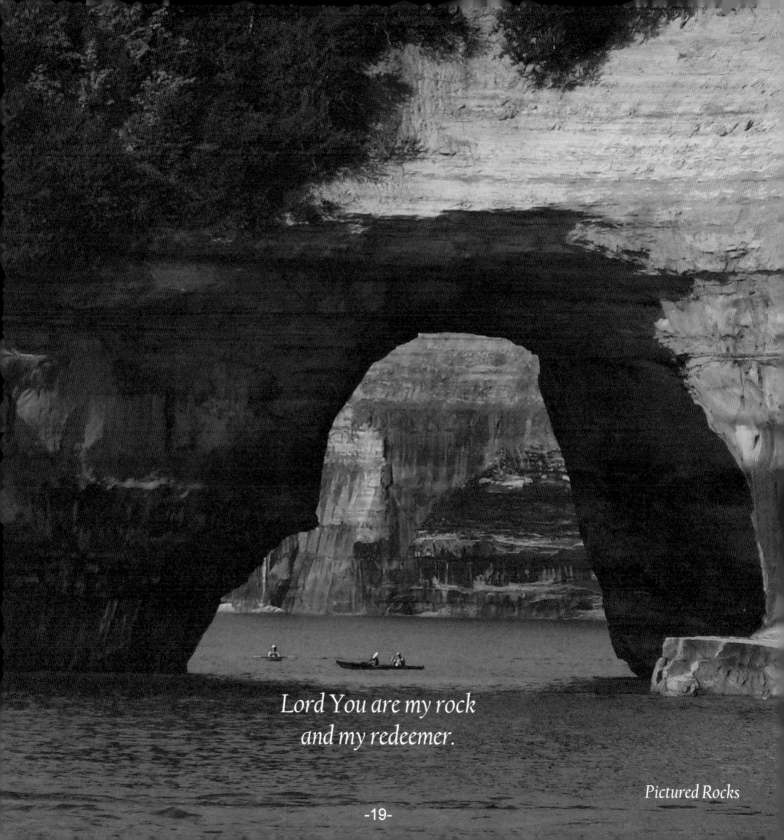

Lord You are my rock
and my redeemer.

Pictured Rocks

With every breath I praise Your holy name.
You are the eternal and everlasting flame.
You open my eyes to the truth of Your word.
Your call to be Holy I have heard.
To be set apart to do Your perfect will
Though the road may be hard, I will follow You still.

Sonora, Arizona

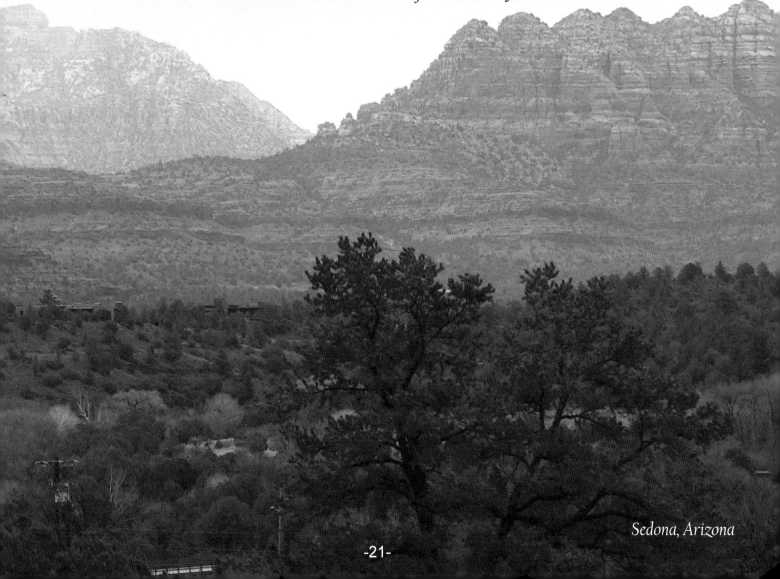

To me You never stop giving.
Each day You make my life worth living.
You carry me in Your hand.
Your thoughts of me are more then all the grains of sand.
You my Lord paid the price for me.
So I can be with You for eternity.

Sedona, Arizona

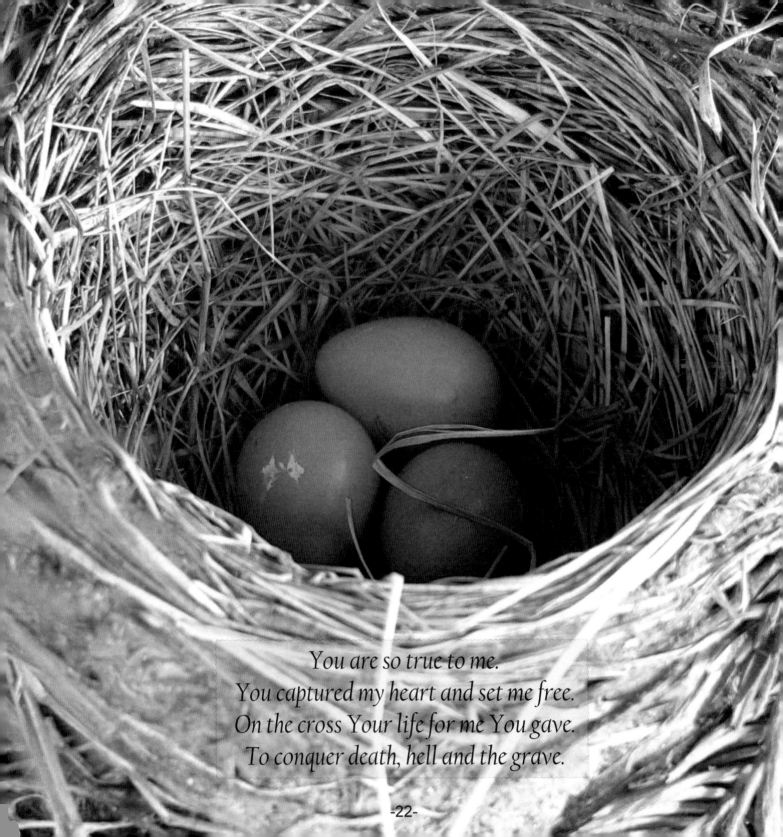

You are so true to me.
You captured my heart and set me free.
On the cross Your life for me You gave.
To conquer death, hell and the grave.

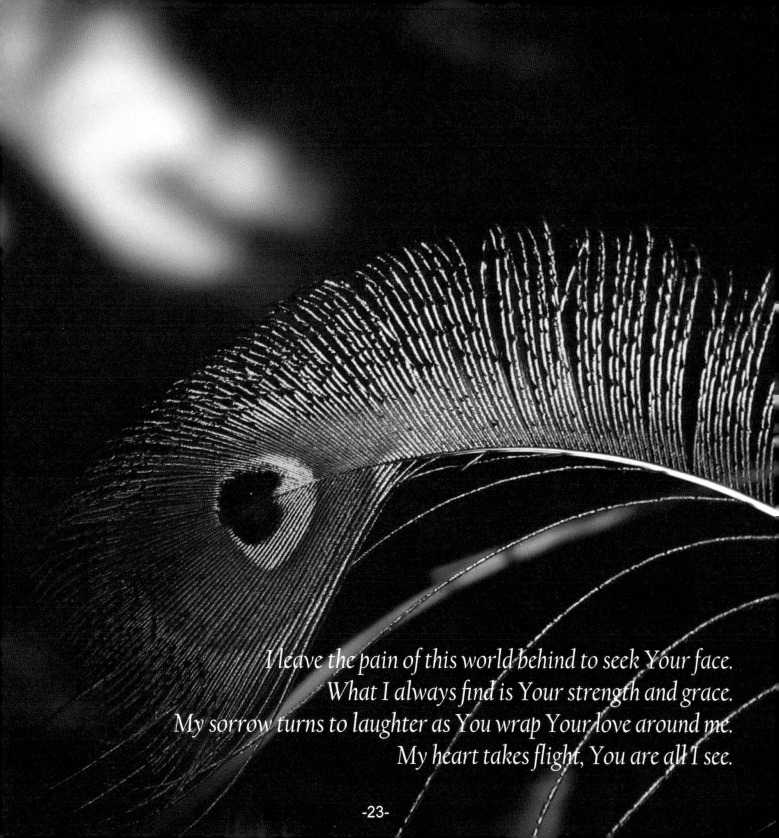

I leave the pain of this world behind to seek Your face.
What I always find is Your strength and grace.
My sorrow turns to laughter as You wrap Your love around me.
My heart takes flight, You are all I see.

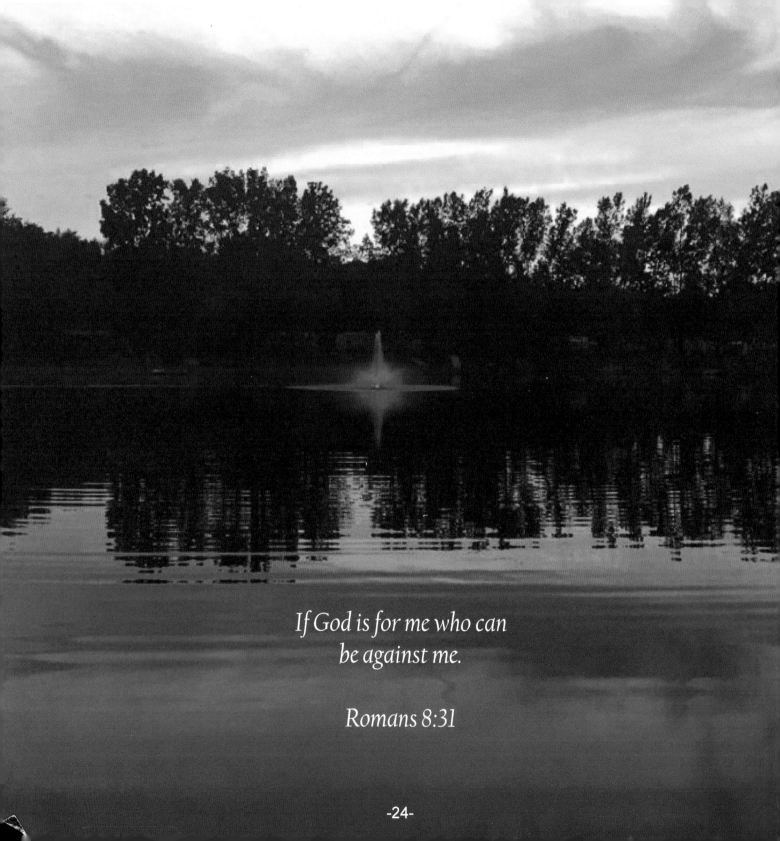

*If God is for me who can
be against me.*

Romans 8:31